MAKE IT!

Movie Props and Special Effects

Anastasia Suen

Rourke
Educational Media

rourkeeducationalmedia.com

SUPPLIES TO COMPLETE ALL PROJECTS:

- actor
- bottles (two 2-liter)
- bottle (third bottle with a different shape)
- cardboard box
- camera
- cell phone or tablet
- duct tape (silver)
- film-editing software
 (ask an adult to download it)
- furniture (optional)
- glitter
- green screen cloth or roll of paper
- hot glue
- life-sized props (optional)
- lights
- masking tape
- measuring tape
- movie set location
- newspaper
- paintbrush
- paint (acrylic)
- paint (spray can)
- paper
- pencil
- plants, dirt, rocks
- Plastalina clay
- scissors
- stickers (numbers and letters)
- stop-motion animation app
 (ask an adult to download it)
- toy animal figurines (dinosaurs, zoo animals, farm animals)
- toy house or miniature town set
- toy vehicle (spacecraft, plane, bus, or car)
- tripod

Table of Contents

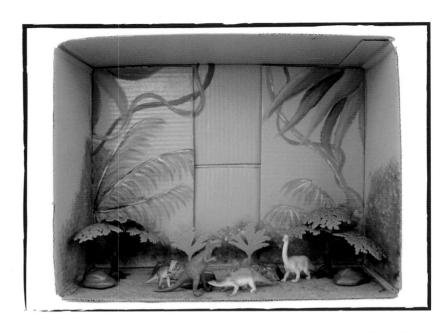

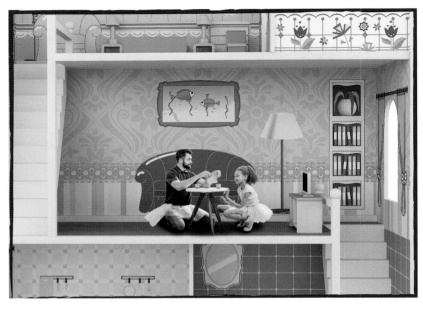

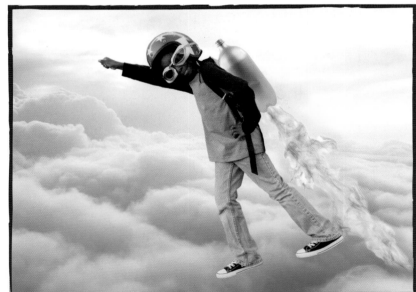

Movie Props and Special Effects

Make your own movie history using props and special effects from classic movies.

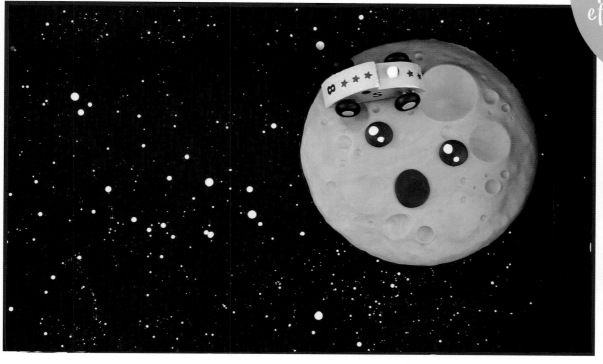

Use items you have around the house to make movie magic! Fly a toy to the moon. Star in your own animal escape movie. Shrink yourself into a movie filmed inside a toy house. Make your actors disappear into thin air. Fly into the future with a jetpack. Let's get started!

Toy Vehicle Miniatures

YOU WILL NEED:

- toy vehicle (spacecraft, plane, bus, or car)
- newspaper
- spray paint
- number and letter stickers
- measuring tape
- cardboard box
- scissors
- small paintbrush
- white acrylic paint
- Plastalina clay
- cell phone or tablet
- tripod
- stop-motion animation app (ask an adult to download it)

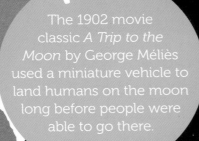

Tip:

The 1902 movie classic *A Trip to the Moon* by George Méliès used a miniature vehicle to land humans on the moon long before people were able to go there.

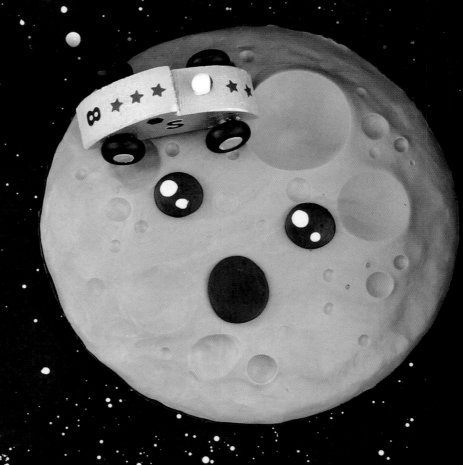

6

FLY A TOY TO THE MOON!

Here's How:

1. Select a toy vehicle that you want to fly to the moon.

2. Transform it into a spacecraft. You can paint it a new color. Or you can add number and letter stickers to give your spacecraft a name.

Tip:
Spray paint the toy vehicle over newspaper in a well-ventilated area. Ask an adult to help you.

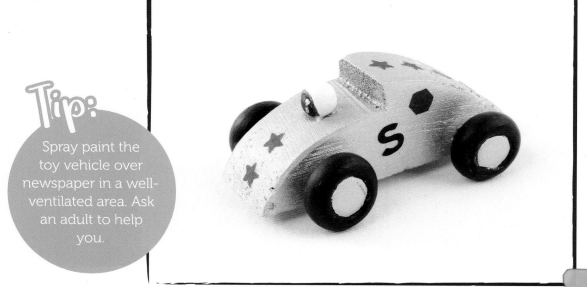

3. Prepare a cardboard box for your movie set. Look for a cardboard box with one side that is three times bigger than your vehicle. Cut it out to make a wide, flat background for your set.

4. Spray one side of the cardboard background with dark blue or black spray paint to create the illusion of outer space.

5. After the paint dries, use a very small brush to paint tiny white dots. These white dots will be the stars in deep space behind the moon.

Tip:

A painting used as a background in a film is called a **matte painting**.

6. Use another piece of cardboard to make a movable base for the moon. Cut a circle from the cardboard.

7. Make a moon with Plastalina clay on the circle. Remember to add craters.

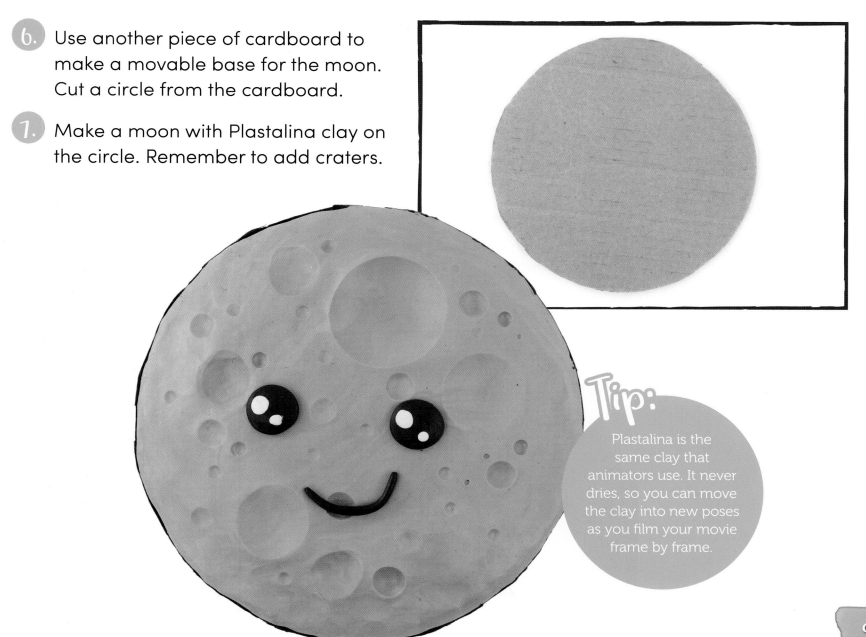

Tip:
Plastalina is the same clay that animators use. It never dries, so you can move the clay into new poses as you film your movie frame by frame.

Film It!

In 1902, George Méliès filmed *Trip to the Moon*, the very first science-fiction movie, using **stop-motion**. You can do the same!

Set up the tripod so the camera looks down at the set. Place the spacecraft at the far edge of the matte painting you made. Use Plastalina clay under the vehicle to hold it in place as needed.

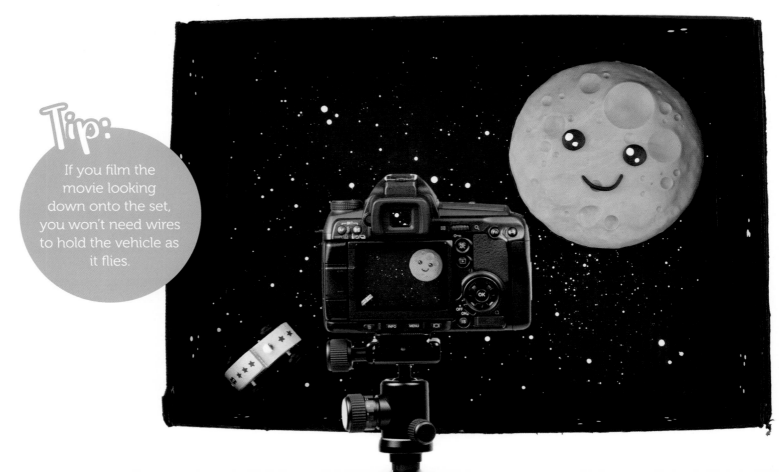

Tip:
If you film the movie looking down onto the set, you won't need wires to hold the vehicle as it flies.

Now turn on the camera and take the first picture. Then stop. Turn the camera off.

Move the spacecraft a tiny bit closer to the moon. Take another picture. Then stop the camera again.

Repeat your stop-motion filming frame by frame as you move the spacecraft across the sky and land it on the moon.

Use the stop-motion animation app to put the images together to make the action come to life!

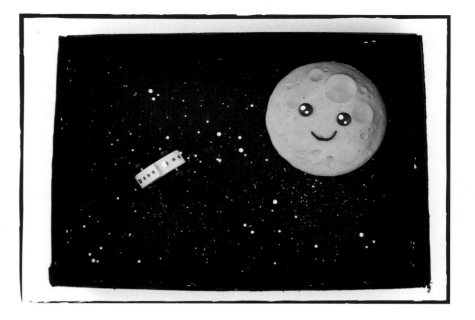

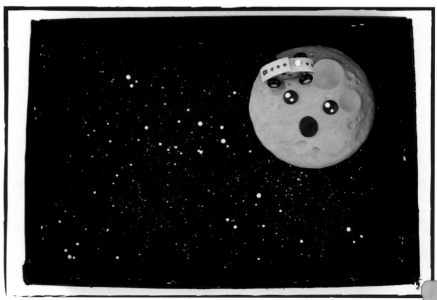

Tip:

Make the moon a character in your movie! Give the moon a face like they did in 1902. Move the animation clay frame by frame to show how the moon felt as the spacecraft flew over and landed on it.

YOU WILL NEED:

- toy animal figurines (dinosaurs, zoo and/or farm animals)
- paper
- pencil
- plants, dirt, rocks
- cardboard box
- scissors
- newspaper
- spray paint
- paintbrush
- acrylic paint
- green screen cloth or roll of paper
- four lights
- masking tape
- camera
- tripod
- film-editing software (ask an adult to download it)

Toy Animal Miniatures

Tip: In the classic movie *Jurassic Park* (1993), dinosaurs came back to life and hunted humans!

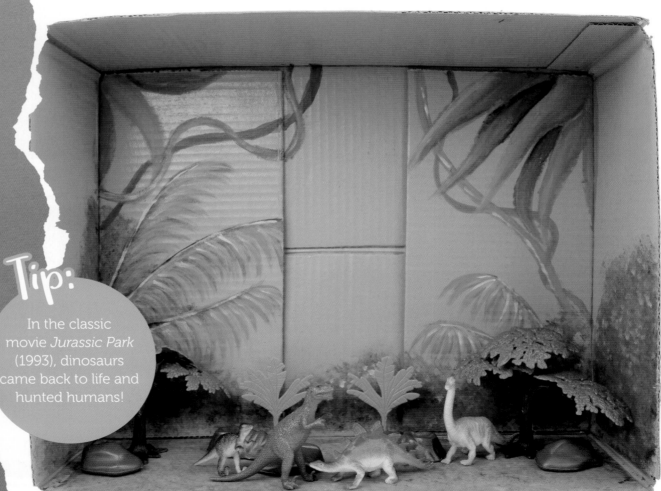

STAR IN YOUR OWN ANIMAL ESCAPE MOVIE!

Here's How:

1. Select a few toy animals for your movie.

2. Think about an escape story you can write for yourself and these characters. Why are these animals chasing you? Write a short movie script.

Tip:

You can star in a movie with miniature characters if you film yourself and the miniatures separately. After you combine the two in editing, it will look like the miniature animals are life-size—and chasing you!

3. **Scout** for an outdoor location to film your movie. Take the animals with you to check the site. Look for a location where the camera will only see plants in the background.

4. If you can't find a location filled with plants, you can make a matte painting for the background. Paint the inside of a cardboard box. Create a miniature world for your toy animals.

Tip:

You can film your movie in the backyard or on a porch with potted plants.

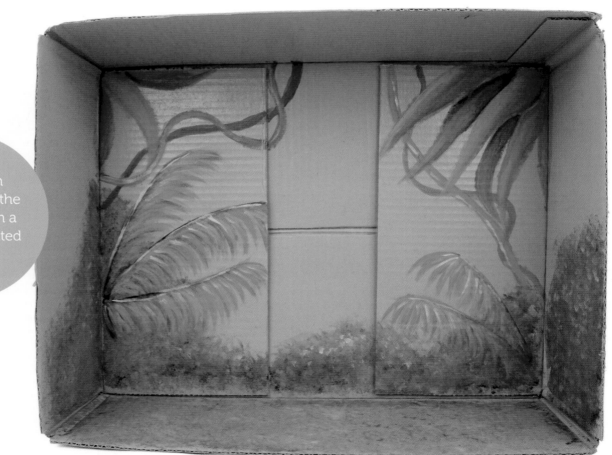

5. Use stop-motion to film the toy animals. Pose the animals and take a picture. Then stop. Turn the camera off.

6. Move the animals a tiny bit. Take a new picture. Then stop the camera again. Repeat your stop-motion filming frame by frame. Slowly move the toys across the movie set.

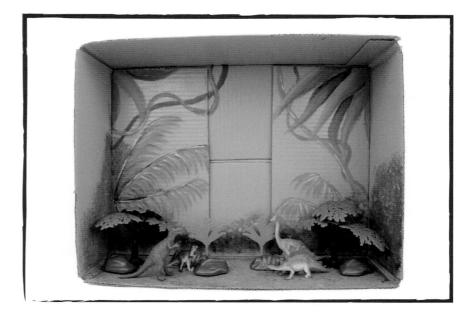

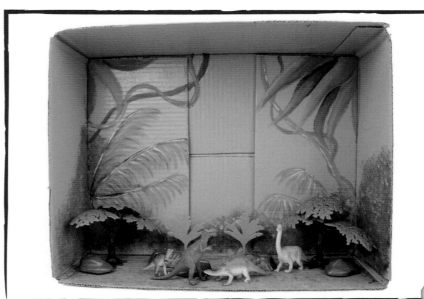

Film It!

Now it's time to add you to the movie! The next step is to film yourself on a green screen so you can escape from the toy animals.

First you will have to make a green screen set. Hang up a long green cloth or roll of paper. Pull it over a door or a tall object like a ladder. Roll it out so it covers some of the floor. Tape everything to hold it in place.

Now add back lights. Place one light on each side of the green screen. Point them at the back of the screen.

Front lights are next. Place the front lights on each side of your green screen set. Point the two front lights so they shine on your face.

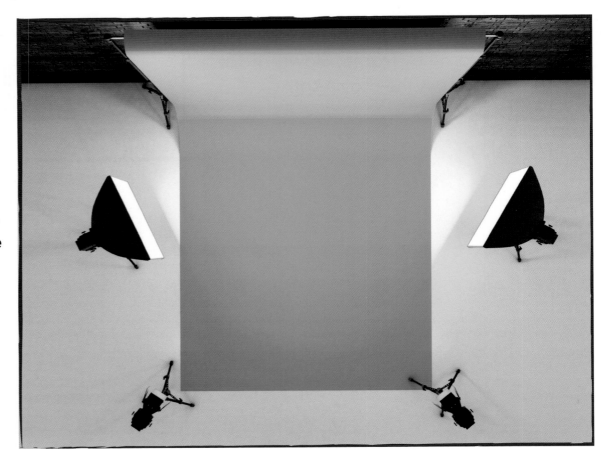

Mount the camera on a tripod in front of your new green screen set.

Before you go on camera, play your stop-motion film to see how long it is. Check the script and make any revisions you need.

Then turn on your camera and start acting! Film your part in front of the green screen.

Use film-editing software to combine your two movies. Because you filmed yourself moving in front of a green screen, it will look like you are on the set with your toy animals!

Tip:

You can download professional film-editing software free online. Look for HitFilm Express and DaVinci Resolve.

Miniature Sets

- small toy house or miniature town set
- paper
- pencil
- green screen cloth or roll of paper
- four lights
- masking tape
- camera
- tripod
- film-editing software (ask an adult to download it)

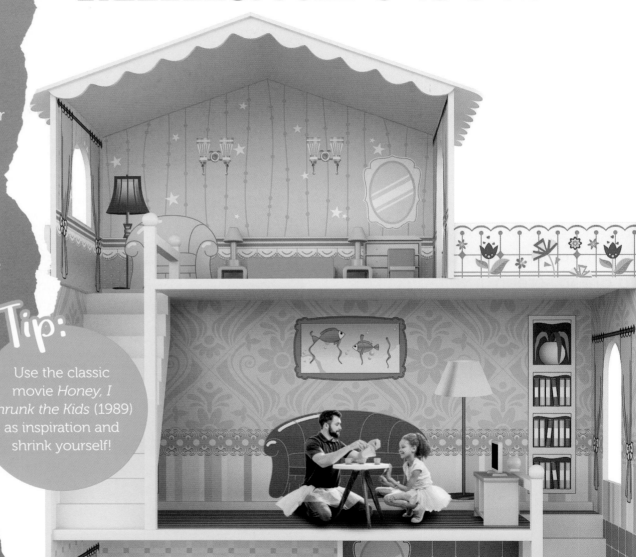

Tip:

Use the classic movie *Honey, I Shrunk the Kids* (1989) as inspiration and shrink yourself!

18

SHRINK YOURSELF INTO A MOVIE FILMED INSIDE A TOY HOUSE!

Here's How:

1. Find a small toy house to use as a movie set. Look for one that opens on one side.

2. Think of a story that can take place inside a house. Write a short movie script.

3. Does your story take place in more than one room? Take a photograph of each room in your story. You will use these photographs as the backgrounds in your movie.

Tip: Do you want someone to act with you? Ask a friend!

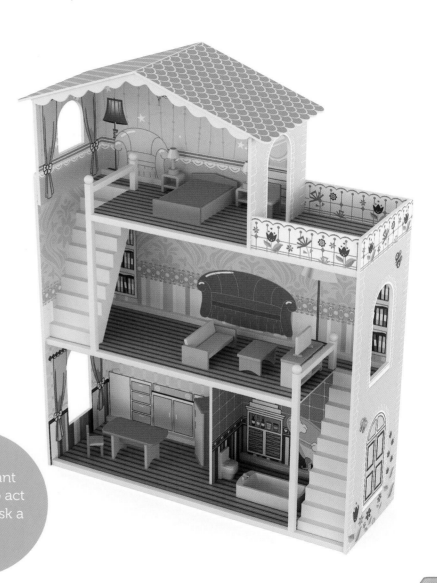

Film It!

4. Make a green screen set. Act out the entire story in front of the green screen.

5. Use film-editing software to combine your green screen movie with the background photographs. Shrink yourself down so you fit on the miniature set.

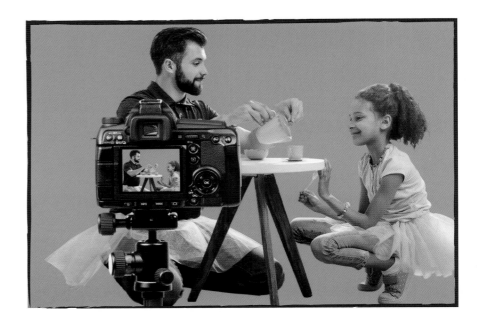

Tip:
When you use an empty dollhouse as your background, you can act out your story in front of the green screen with real furniture and other life-sized objects.

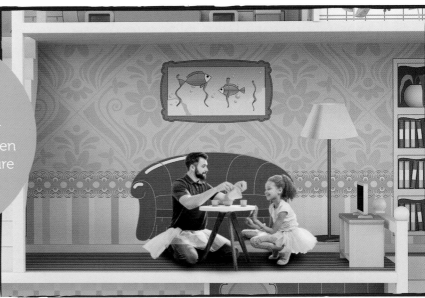

Do you know someone who collects miniatures? Ask them if you can use their miniature village as your film set! Some collectors add miniature buildings to their train sets. Others collect miniature buildings to create winter scenes for the holiday season.

These miniature buildings often have lights inside. Turn them on before you start filming. This will make it look like someone is inside the tiny buildings.

Just as you did with the dollhouse, photograph each part of the set you want to use as a background. Move in close when you take these shots so you won't have to remove **extraneous** items in the room from your background photograph.

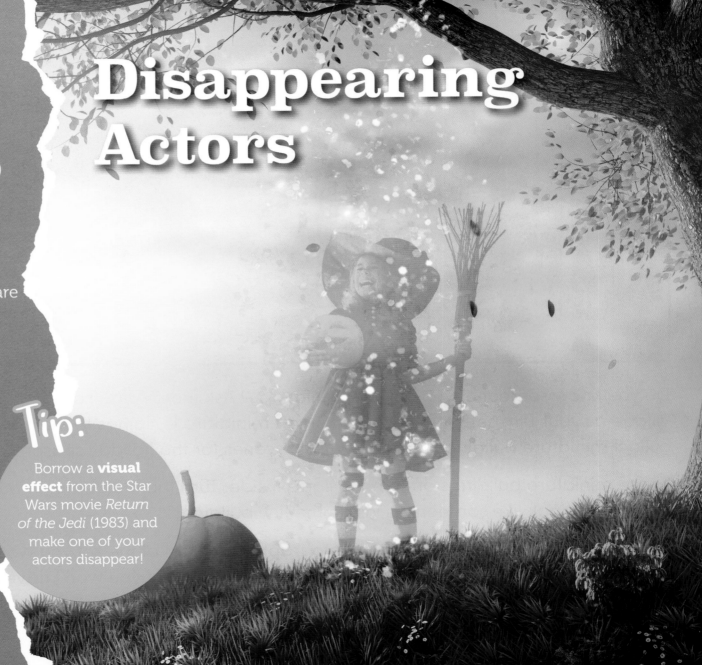

Disappearing Actors

YOU WILL NEED:

- actor
- movie set
- furniture (optional)
- life-sized props (optional)
- camera
- tripod
- film-editing software (ask an adult to download it)
- glitter
- black paper
- bright light

Tip:

Borrow a **visual effect** from the Star Wars movie *Return of the Jedi* (1983) and make one of your actors disappear!

22

MAKE YOUR ACTORS DISAPPEAR INTO THIN AIR.

Here's How:

1. Think of a story where an actor can disappear. Write a short movie script.

2. Decide on the actor's pose. Will the actor lie down or stand in place? What expression will be on the actor's face?

3. Set up the tripod to film your scene. Turn off the auto exposure on your camera.

Tip: The auto exposure bracketing (AEB) setting on your camera adjusts the lighting of your scene. When someone comes into view or leaves the scene, the settings change. If the settings are different for each shot, it will be harder to **blend** the two shots in editing.

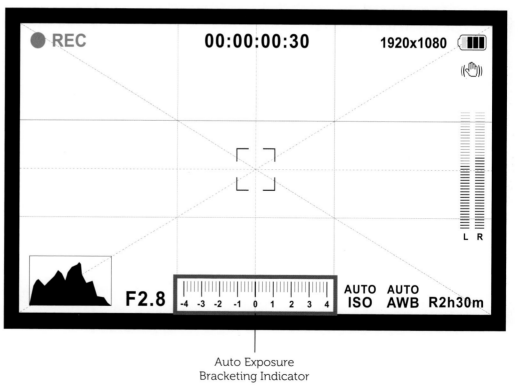

REC 00:00:00:30 1920x1080

L R

F2.8 -4 -3 -2 -1 0 1 2 3 4 AUTO ISO AUTO AWB R2h30m

Auto Exposure Bracketing Indicator

Film It!

4. Film the actor on the set. Stop the camera.

5. Ask the actor to leave the scene. Film the empty set without the actor.

6. Use editing software to make the actor fade away.

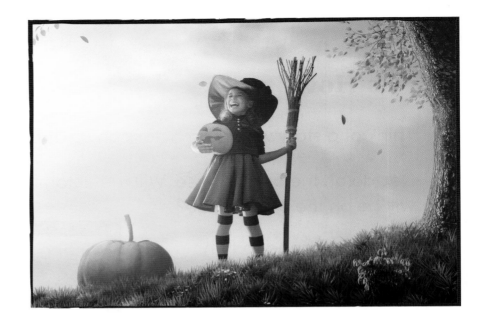

Tip:

To make an actor fade away, begin editing with the shot where the actor is in the scene. Use the editing software to make the actor's body slowly fade away. The shot without the actor will be the final one for that scene.

After you try that visual effect, reverse the process and make an actor appear out of nowhere! Write another script and have your actor fade in instead. This is how people traveled in and out of the *Starship U.S.S. Enterprise* (NCC-1701) in the classic television show *Star Trek* (1966). They used this method of transport in the *Star Trek* movies, too.

Tip:

If you want to make the air around your actor sparkle when they appear or disappear like they did on Star Trek, borrow their special effect. Drop glitter on a sheet of black paper and film it falling in a very bright light. Add the shiny falling glitter effect to the scene as you edit.

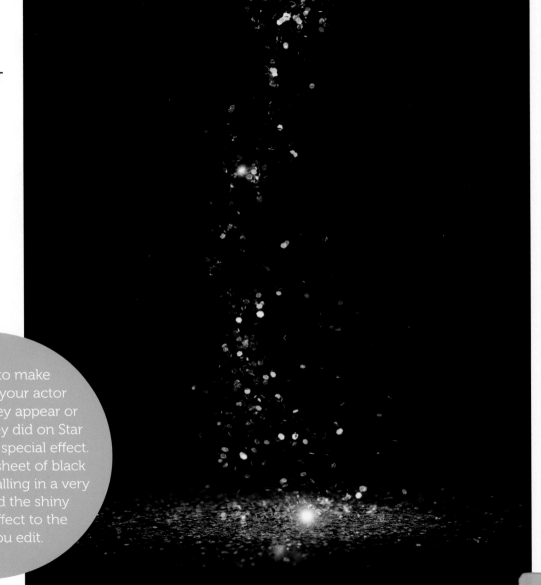

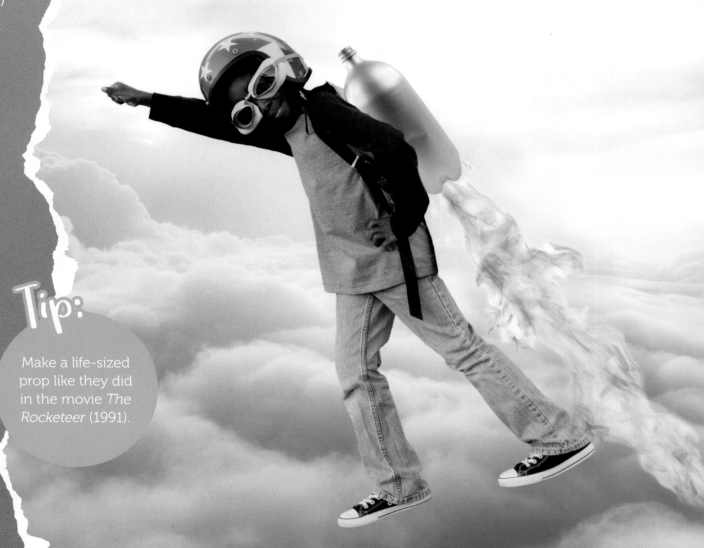

Life-Size Props

YOU WILL NEED:

- 2-liter bottles (two)
- third bottle (with a different shape)
- cardboard
- scissors
- pencil
- measuring tape
- hot glue
- silver spray paint
- newspaper
- silver duct tape

Tip:

Make a life-sized prop like they did in the movie *The Rocketeer* (1991).

FLY INTO THE FUTURE WITH A JETPACK.

Here's How:

1. Place the three bottles on the table side by side. Measure how much space the three bottles cover. Measure the height and width.

2. Cut a sheet of cardboard that will fit underneath all three bottles when they are laid flat.

3. Paint the cardboard and the three bottles silver.

Tip:

Spray paint the cardboard and the three bottles over newspaper in a well-ventilated area. Ask an adult to help you.

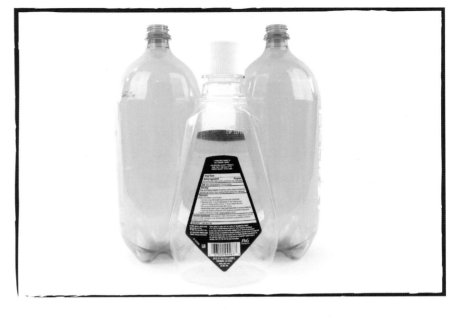

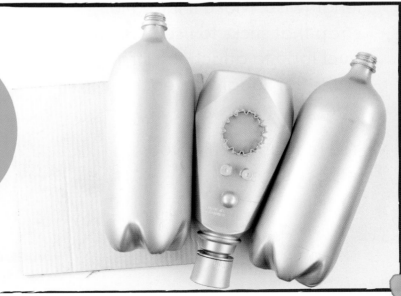

27

4. Use hot glue to attach all three bottles to the cardboard and to each other. Ask an adult to help you.

5. Hold the jetpack on the actor's back. Use the measuring tape like a backpack strap. Measure how long the silver duct tape strap will need to be.

6. Fold each duct tape strap in half lengthwise. Make it into a long strap that sticks to itself. Use more duct tape to attach the strap to the cardboard on each side.

7. You're ready to film your jetpack scene!

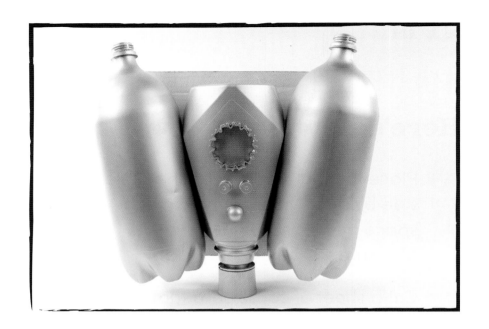

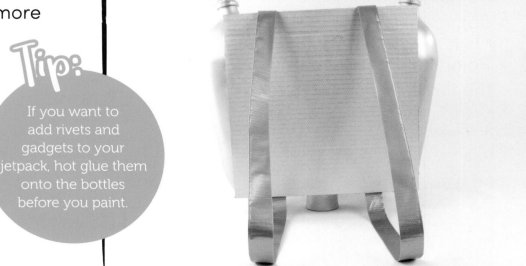

Tip:
If you want to add rivets and gadgets to your jetpack, hot glue them onto the bottles before you paint.

Film It!

After you film your jetpack scene, you can add more effects in editing. Some fun visual effects to add might be bursts of flame or plumes of smoke coming from the bottom of the jetpack.

You can also add sound effects to your movie. Do you want to hear the rockets roar to life as your actor takes off with the jetpack? Maybe you want to hear the engines rumble or whoosh as the actor flies the jetpack across the screen.

There are free files online for moviemakers like you. Look for VFX (visual effects) and SFX (sound effects) files. Ask an adult to help you download the files.

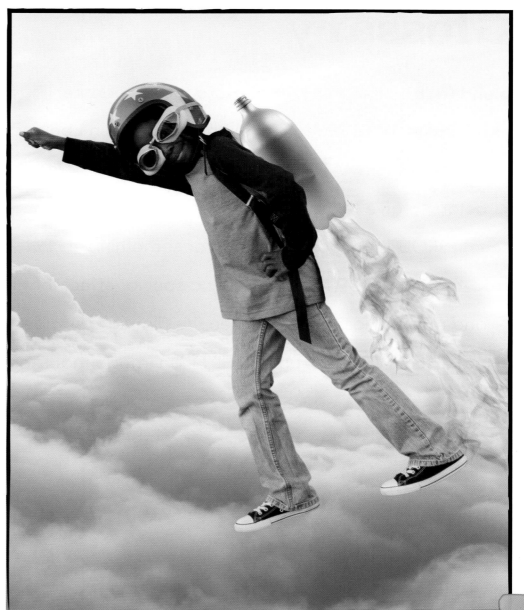

Glossary

blend (BLEND): to mix two or more things together

extraneous (ik-STREY-ne-uhs): things that don't belong

matte painting (MAT PEYN-ting): a landscape or location painted and placed behind the actors to give the illusion that the movie is taking place there

scout (SKOUT): to look or search for something

stop-motion (STOP MOH-shuhn): a special effect that films objects one frame at a time and moves those objects when the filming is stopped

visual effect (VIZH-oo-uhl ih-FEKT): an image that is added to a film during editing

Index

Show What You Know

1. Why is it important to use clay that never dries for your special effects?

2. How can editing help you shrink yourself into a tiny movie set?

3. Why is it possible for you to use life-size props when you film a movie for a tiny background set?

4. What happens when you leave the auto-exposure setting in the camera turned on?

5. What other effects can you add to your film during the editing process?

Further Reading

Bellmont, Laura and Brink, Emily, *Animation Lab for Kids: Fun Projects for Visual Storytelling and Making Art Move—From Cartooning and Flip Books to Claymation and Stop-Motion Movie Making*, Quarry Books, 2016.

Blofield, Robert, *How to Make a Movie in 10 Easy Lessons: Learn How to Write, Direct, And Edit Your Own Film Without A Hollywood Budget*, Walter Foster Jr, 2015.

Pagano, David and Pickett, David, *The LEGO Animation Book: Make Your Own LEGO Movies!*, No Starch Press, 2016.

About the Author

Anastasia Suen is the author of more than 300 books for young readers. As a child, she lived in North Hollywood, where the Academy of Television Arts & Sciences (that awards the Emmys) is located. A lifelong television and movie fan, she watches television and movies from her home in Northern California.

Meet The Author!
www.meetREMauthors.com

© 2019 Rourke Educational Media

www.rourkeeducationalmedia.com

PHOTO CREDITS: Cover, 4, 5, 6, 7, 8, 9, 10, 11, 12, 13, 14, 15, 26, 27, 28, 29: © creativelytara; Page 4: © arsa35, LightFieldStudios, nevodka, Choreograph, Rich Vintage, Antagain, Anna_Om; Page 13: © Fat Camera; Page 16: © ilyarexi; Page 17: © Leslie Lauren, grady reese, GetUpStudio; Page 18: © arsa35, LightField Studios; Page 19: © arsa35; Page 20: © Leslie Lauren, GetUpStudio, LightField Studios; Page 21: © Frank Vanden Bregh; Page 22: © Choreograph, nevodka; Page 24: © Choreograph; Page 25: © nevodka, Page 26 & 29: © Rich Vintage, Antagain, Anna_Om

Edited by: Keli Sipperley
Cover and Interior design by: Tara Raymo • CreativelyTara • www.creativelytara.com

Library of Congress PCN Data

Movie Props and Special Effects / Anastasia Suen
(Make It!)
 ISBN 978-1-64156-445-8 (hard cover)
 ISBN 978-1-64156-571-4 (soft cover)
 ISBN 978-1-64156-690-2 (e-Book)
Library of Congress Control Number: 2018930473

Rourke Educational Media
Printed in the United States of America,
North Mankato, Minnesota